OUTLINE ALPHABETS

100 COMPLETE FONTS

OUTLINE ALPHABETS

100 COMPLETE FONTS

Selected and Arranged by

DAN X. SOLO

from the Solotype Archive

DOVER PUBLICATIONS, INC. · NEW YORK

Copyright © 1988 by Dover Publications, Inc.
All rights reserved under Pan American and International Copyright Conventions.

Published in Canada by General Publishing Company, Ltd., 30 Lesmill Road, Don Mills, Toronto, Ontario.
Published in the United Kingdom by Constable and Company, Ltd.

Outline Alphabets: 100 Complete Fonts is a new work, first published by Dover Publications, Inc., in 1988.

Manufactured in the United States of America
Dover Publications, Inc., 31 East 2nd Street, Mineola, N.Y. 11501

DOVER *Pictorial Archive* SERIES

Library of Congress Cataloging-in-Publication Data

Outline alphabets : 100 complete fonts / selected and arranged by Dan X. Solo from the Solotype Typographers catalog.
 p. cm. — (Dover pictorial archive series)
 ISBN 0-486-25824-6 (pbk.)
 1. Type and type-founding—Outline type. 2. Printing—Specimens.
3. Alphabets. I. Solo, Dan X. II. Solotype Typographers. III. Series.
Z250.5.O87093 1988
 686.2'24—dc19 88-22612
 CIP

Albertus Outline

ABCDEFGHIJ
KLMNOPQRST
UVWXYZ

abcdefghijklmn
opqrstuvwxyz

$1234567890

&,!?

Americana Outline

ABCDEFGH
IJKLMNOPQ
RSTUVW
XYZ
abcdefghijkl
mnopqrstu
vwxyz
£1234567890$
(&.,;;!?¿'"''—–·*)

Anzeigen Grotesque Outline

ABCDEFGHIJKLMN
OPQRSTUVWXYZ

aabcdefghijklm
nopqrstuvwxyz

£1234567890$

(&.,,:;!?'''""—[]*")

Aquarius Outline

ABCDEFG

HIJKLMNOPQRST

UVWXYZ

$¢%/

(&.,:;'"''!?---·*)

abcdefghijklmnopq

rstuvwxyz

£1234567890

Arpad Outline

ABCDEFG
HIJKLMNOPQ
RSTUVW
XYZ
(&.:;"-'!?)

abcdefghijklmno
pqrstuvwxyz
$1234567890¢

Aster Outline

ABCDEFGH
IJKLMNOPQR
STUVWXYZ
abcdefghijkl
mnopqrstuvw
xyz
£1234567890$
(&.,:;!?'''""*)

Aurelio Outline

ABCDEFGHIJ
KLMNOPQRSTU
VWXYZ
(&.,:;!?"")

abcdefghijklmn
opqrstuvwxyz

$1234567890

Auriol Outline

ABCDEFGH
IJKLMNOPQ
RSTUVWXY
Z

abcdefghijkl
mnopqrsſtũuv
wxyz-';.:!?⁂«»()

1234567890

Baker Danmark Outline

ABCDEFGHIJK
LMNOPQRS
TUVWXYZ

abcdefghijklmn
opqrstuvwxyz
£1234567890$
(&.,°°!?°,,*)

Baskerville Outline

ABCDEFGH
IJKLMNOPQR
STUVWXYZ
(&.,;:!?'"*)

abcdefghijklmn
opqrstuvwxyz

£1234567890$

Bauer Topic

ABCDEFGHIJKLMN
OPQRSTUVWXYZ

abcdefghijklmnop
qrstuvwxyz

$1234567890
&;!?

Bauhaus Outline

ABCDEFGHIJKLMM
NNOPQRSSTUV
WXXYZ
abcdeefghijklmn
opqrrsstuvwxxyyz

(&&:;!?*)
1234567890

Ben Franklin Open

ABCDEFGHIJ
KLMNOPQRST
UVWXYZ

abcdefghijklmn
opqrstuvwxyz
$1234567890
&,!?

BOLD SANS OUTLINE

ABCDEFGHI
JKLMNOPQRS
TUVWXYZ

1234567890

Bookman Bold Outline

AA ABB CD D

E EF FGH HI IJ J

K KL LM M M MN

NOP PQR RR S

TU U V V W W

X XY YZ

abcdefghijklmn

opqrrstuvwxyyz

1234567890$&@,;!?

15

Bridger Outline

ABCDEFG
HIJKLMNOPQR
STUVWXYZ
(&.,,:;!?"‘’"*)

abcdefghijklmno
pqrstuvwxyz

£1234567890$

CAROLUS OUTLINE

ABCDEFGH
IJKLMNOP
QRSTUVW
XYZ$¢%

(&.:;'"'''''''*)

1234567890

CENTRIC

ABCDEFG

HIJKLMN

OPQRSTU

VWXYZ &

Cheltenham Bold

CONDENSED OUTLINE

ABCDEFGHIJK
LMNOPQRST
UVWXYZ
&,!?
abcdefghijklmn
opqrstuvwxyz
$1234567890

Cheltenham Bold

EXTENDED OUTLINE

ABCDEFGHIJ
KLMNOPQRS
TUVWXYZ

abcdefghijklmn
opqrstuvwxyz

$1234567890
&,!?

Clearface Outline

ABCDEFGH
IJKLMNOPQR
STUVWXYZ

abcdefghijkl
mnopqrstu
vwxyz&;!?
$1234567890

Cloister Outline

ABCDEFGH
IJKLMNOPQRS
TUVWXYZ

abcdefghijklmn
opqrstuvwxyz
(&;!?)
$1234567890

COLUMNA OUTLINE

ABCDEFGH
IJKLMNOPQ
RSTUV
WXYZ
(&;!?)

$1234567890

Contact Outline

ABCDEFGHIJK
LMNOPQRST
UVWXYZ&:;,!?

abcdefghijklmn
opqrstuvwxyz

$1234567890

CONTOUR

ABCDEFGHI
JKLMNOPQRS
TUVWXYZ

?-,;:!

1234
567890

Contoura

ABCDEFG
HIJKLMNOPQR
STUVWXYZ

abcdefghijklm
nopqrstuvwxyz

$1234567890

&;!?

Cooper Black Outline

ABCDEFGH
IJKLMNOPQR
STUVWXYZ
{&.,;:;!?'("")-*}

abcdefghijklm
nopqrstuvw
xyz

1234567890$

Cooper Black Italic

ABCDEFGHI
JKLMNOPQRS
TUVWXYZ

abcdefghijklmn
opqrstuvwxyz

$1234567890
&;!?

COUNTRY BARNUM

ABCDE

FGHIJKLM

NOPQRSTU

VWXYZ

Craw Clarendon

ABCDEFGH
IJKLMNOPQ
RSTUVW
XYZ

abcdefghijkl
mnopqrstuv
wxyz

(&.,:;-''!?$¢%)
1234567890

30

Cursillo Outline

ABCDEFGHIJK
LMNOP
QRSTUVW
XYZ

[&:;!?'‚""‛]

aabcdeffgghijklm
nopqrrstuv
wxyyz

1234567890

Cushing Old Style

OUTLINE

ABCDEFGHIJKL
MNOPQRSTUV
WXYZ
(&.,,:!?''""*)

abcdefghijklmn
opqrstuvwxyz

1234567890$$¢%

DELPHIAN

ABCDEF

GHIJKLM

NOPQRS

TUVW

XYZ

1234567890

33

Dominante Outline

ABCDEFGHI
JKLMNOPQRS
TUVWXYZ

abcdefghijklm
nopqrstuv
wxyz

$1234567890
&;!?

DOUBLE MINT

ABCDEFG

HIJKLM

NOPQRSTU

VWXYZ

Egyptian 505 Outline

ABCDEFGHIJ
KLMNOPQRST
UVWXYZ
abcdefghijklmn
opqrstuvwxyz

$1234567890
&,!?

Elmont Outline

ABCDEFGHI
JKLMNOPQRST
UVWXYZ

abcdefghijklmn
opqrstuvwxyz

1234567890
&.,:;!?

◁ ◁ EPITAPH OPEN ▷ ▷

ABCDEFG

HIJKLMN

OPQRSTU

VWXYZ&

Eras Outline

ABCDEFGHIJ

KLMNOP

QRSTUVW

WXYZ&;!?

aabcdefghijk

lmnopqrst

uvwxyz

$1234567890

Erbar Outline

ABCDEFGHIJK
LMNOPQRST
UVWXYZ

abcdefghijklmn
opqrstuvwxyz
(&.,:;!?""-")
$1234567890

Eurostile Bold Outline

ABCDEFG
HIJKLMNOPQR
STUVWXYZ

abcdefghijklm
nopqrstuvwxyz

1234567890

(&$¢$.,.;"'!?-)

Folio Ex. Bold Outline

ABCDEFGHIJ
KLMNOPQRSTU
VWXYZ
(&:;!?'""—*.)

abcdefghijklmn
opqrstuvwxyz

$1234567890

Franklin Outline

ABCDEFGH
IJKLMNOPQRST
UVWXYZ

(&;:'''''"!?*")
-.!?

abcdefgghijklmn
opqrstuvwxyz
$1234567890

Futura Black
OUTLINE

ABCDEFGHI
JKLMNOPQR
STUVWXYZ
abcdefghijklm
nopqrstuvw
xyz
1234567890
(&$.;!?")")

Futura Bold

ABCDEFGHI
JKLMNOPQR
STUVWXYZ

abcdefghijklmn
opqrstuvwxyz
1234567890
&;!?

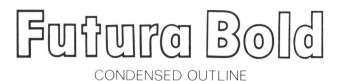

Futura Bold
CONDENSED OUTLINE

ABCDEFGHIJKLM
NOPQRSTUVWXYZ
(&.,.,.!?'ÜÜ'"*)

abcdefghijklmn
opqrstuvwxyz

1234567890$¢

FUTURA INLINE

ABCDEFG
HIJKLMNOP
QRSTUVW
XYZ

(&.,.:;!?"""*)

$1234567890

Garamond Outline

ABCDEFG
HIJKLMNOPQR
STUVWXYZ

abcdefghijklm
nopqrstuvwxyz

$1234567890
&,·!?

GILL FLORIATED

ABCDEFGH
IJKLMNOPQ
RSTUVW
XYZ

Globe Gothic Outline

ABCDEFGHIJK
LMNOPQRS
TUVWXYZ&,!?

abcdefghijklmn
opqrstuvwxyz

$1234567890

Goudy Bold Outline

ABCDEFG
HIJKLMNOPQ
RSTUVWXYZ
abcdefghijkl
mnopqrstuvw
xyz
$1234567890
&;!?

Grafito Outline

ABCDEFGH
IJKLMNOPQRS
TUVWXYZ
abcdefghijklm
nopqrstuvwxy
z

$1234567890

&,!?

Granby Outline

ABCDEFGHIJ
KLMNOPQRS
TUVWXYZ

abcdefghijkl
mnopqrstu
vwxyz

1234567890
(&;!?')

Headline Open

ABCDEFGHIJKLM
NOPQRSTUVWXYZ
&S!?

aabcdefgghijjklmno
ppqqrstuvwxyyz

1234567890

Helvetica Bold Condensed Outline

ABCDEFGHIJKL
MNO
PQRSTUVWXYZ

abcdefghijklmn
opqrstuvwxyz

£1234567890$

[&.,:;''""!?---*]

Helvetica Medium Outline

ABCDEFGHI
JKLMNOPQR
STUVWXYZ

abcdefghijklm
nopqrstuvw
xyz

$1234567890

(&.,;:;"'!?-)

Hobo Outline

ABCDEFGHIJK
LMNOPQRSTU
VWXYZ

abcdefgghijkl
mnoppqqrstu
vwxyyz

$1234567890

(&.,:;!?'-*')

Hollandse Outline

ABCDEFGH
IJKLMNOPQ
RSTUVW
XYZ&;!?
abcdefghijklm
nopqrrstuvw
xyz
$1234567890

Howland Open

ABCDEFGHIJK
LMNOOPQRS
TUVWXYZ&,!?

abcdefghijklm
nopqrstuvwxyz

$1234567890

Impact Outline

ABCDEFGHIJJK
LMNOPQRSTUV
WXYZ(&:;!?'""-)

abcdefghijklm
nopqrrstu
vwxyz
$1234567890

INFLATION

A B C D E F G
H I J K L M N
O P Q R S T U
V W X Y Z &
1 2 3 4 5
6 7 8 9 0

[$ ¢ % : ; ! ?]

Jay Gothic Outline

ABCDEFGHIJKLMN
OPQRSTUVWXYZ

§

abcdefghijklmnop
qrstuvwxyz

$1234567890

Jenson Outline

ABCDEFGH
IJKLMNOPQR
STUVWXYZ
&;!?

abcdefghijklmn
opqrstuvwxyz
$1234567890

Jolsen Soprano

ABCDEFGHI
JKLMNOPQRS
TUVWXYZ

~

abcdefghijkllm
nopqrrstuvwxyz

&,!!?
$1234567890

Kable Outline

ABCDEFGHIJK
LMNOPQRSTUV
WXYZ
abcdefghijklmn
opqrstuvwxyz

$1234567890

&&¿!?

Kennerly Outline

ABCDEFG
HIJKLMNOP
QRSTUV
WXYZ
abcdefghijklm
nopqrstuvwxyz
(&;!?)
$1234567890

Korinna Bold Outline

ABCDEFGHI
JKLMNOPQR
STUUVWXYZ
abccdeefghiij
jklmnopqrsstu
vwxyz
$1234567890
&;::!?

LARGO BOLD

OUTLINE

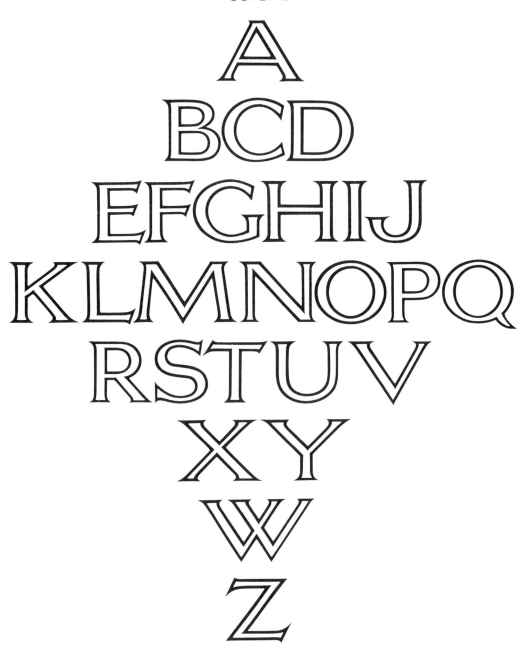

A
BCD
EFGHIJ
KLMNOPQ
RSTUV
XY
W
Z

1234567890

Latwist

ABCDEFGHIJ
KLMNOPQRSTUV
WXYZ

abcdeefghijklm
nopqrstuvwxyz
&;!?
$1234567890

Looking Glass Outline

ABCDEFGHIJ
KLMNOPQRST
UVWXYZ
abcdefghijklm
nopqrstuvw
xyz
$1234567890
&,:!!!?

Lubalin Graph

OUTLINE

ABCDEFGH
IJKLMNOPQRS
T
UVWXYZ
abcdefghijklm
nopqrstuvwxyz
£1234567890$

MANDARIN OUTLINE

ABCDEFGHI
JKLMNOPQR
STUVWXYZ

$1234567890

&!?

Marschall Outline

ABCDEFGHIJKLMN
OPQRSTUVWXYZ

abcdefghijklmnop
qrstuvwxyz

1234567890$&;-''!?

MARVAL

ABCDEFGHI
JKLMNOPQR
STUVWXYZ

1234567890
(&.,;;'!?)

MICROGRAMA BOLD

OUTLINE

ABCDEFGHIJ
KLMMMNOPQR
RSTUVWXY
Z&,!?$

1234567890

New House Outline

ABCDEFGHIJ
KLMNOPQRSTUV
WXYZ
abcdefghijkl
mnopqrstuvwxyz

1234567890
$¢

Normandie Open

ABCDEFG
HIJKLMNOPQR
STUVWXYZ

abcdefghij
klmnopqrstu
vwxyz

1234567890

&$;!?

OLD VIC
OUTLINE

ABCDEFGH
IJKLMNOPQ
RSTUVW
XYZ&
(?!'' ,:;-$¢)

1234567890

78

Olive Antique

OUTLINE

ABCDEFGHIJ
KLMNOPQRST
UVWXYZ

abcdefghijkl
mnopqrstu
vwxyz

$1234567890
&,!?

Optima Semibold Outline

ABCDEFGHIJK
LMNOPQRSTUV
WXYZ

abcdefghijklmn
opqrstuvwxyz
&¿!?
$1234567890

Othello Outline

ABCDEFGHIJKLM
NOPQRSTUVWXYZ

abcdefghijklmn
opqrstuvwxyz
&;!?
$1234567890¢

Pluto Outline

ABCDEFG
HIJKLMNOPQRST
UVWXYZ
(&:;"'!?)

abcdefghijklmno
pqrstuvwxyz
$1234567890

ABCDEFGHIJ

KLMNOPQRS

TUVWXYZ

&;!?

$1234567890

Richmond Outline

ABCDEFGH
IJKLMNOPQR
STUVWXYZ
abcdefghijklm
nopqrstuv
wxyz

$1234567890

(&.,:;!?'"-)

Rolling Outline

ABCDEFGH
IJKLMNOPQR
STUVWXYZ

abcdefghijkl
mnopqrstu
vwxyz

&.,;:"'!?

$1234567890

Roslyn Gothic Outline

ABCDEFGHIJKLM
NOPQRSTUVWXYZ

abcdefghijklmn
opqrstuvwxyz
& .,.:!?

$1234567890

Serif Gothic Outline

AABCDEEFGHIJ
KLLMMNNOPQR
STUVVWWXYZ

aabcdeeffghijkk
lmnopqrrsʃttu
vvwwxyzz

&;'$!?

11234445678890

sintex outline

ABCDEFG
HIJKLMNOPQRS
TUVWXYZ

abcdefghijklm
nopqrstuvwxyz

&

$1234567890.,!?

Souvenir Outline

AAaBCDEEFG

GHIJKLMMNN

OPQRSSTTU

VWXYZ&;!?

abcdefghhiijkl

mmnnopqrfs

stuvwxyz

$1234567890

Stephania Outline

ABCDEFGH
IJKLMNOPQR
STUVWXYZ

abcdefghijklmn
opqrstuvwxyz

$1234567890
&;!?

Tamil Outline

ABCDEFGHIJKK
LMNOPQRSST
UVWXYZ&;!?

abcdeefgghijkl
mnopqrsstuvw
xyyz

$1234567890

Triplett Outline

ABCDEFGHI
JKLMNOPQR
STUVWXYZ
abcdefghijkl
mnopqrstu
vwxyz
&,;!?
$1234567890

Univers 75 Outline

ABCDEFGHIJK
LMNOPQRST
UVWXYZ
abcdefghijklm
nopqrstuv
wxyz
$1234567890
(&;!?)

VERONICA OPEN

ABCDEFGHI
JKLMNOPQRS
TUVWXYZ

1234567890
&!?""$¢

Wandsworth Outline

ABCDEFGH
IJKLMNOPQRS
TUVWXYZ

abcdefghijklmn
opqrstuvwxyz
$1234567890
(&!?""''*)

WASHINGTON OUTLINE

ABCDEFGHIJK
LMNOPQ
RSTUVWXYZ

1234567890

(&.,:;-''!?*)

Whitin Outline

ABCDEFGH
IJKLMNOPQ
RSTUVW
XYZ
abcdefghijkl
mnopqrstu
vwxyz

1234567890
(&.,;:!?"-)

Wide Latin
Outline

ABCDEF
GHIJKLM
NOPQRST
UVWXYZ

abcdefghij
klmnopqr
stuvwxyz

1234567
7890

¢%

(&.,:;-""'!?)

Windsor Outline

ABCDEFGH
IJKLMNOPQRS
TUVWXYZ

abcdefghijklmno
pqrstuvwxyz

(&.,""!?-$$¢*)
1234567890

Wurstell
Outline

aAbBcDdeeFG
HIiijKkLmNNo
ppQqrrstt
Uvwxyz
(&;!?)

$1234567890